T0169388

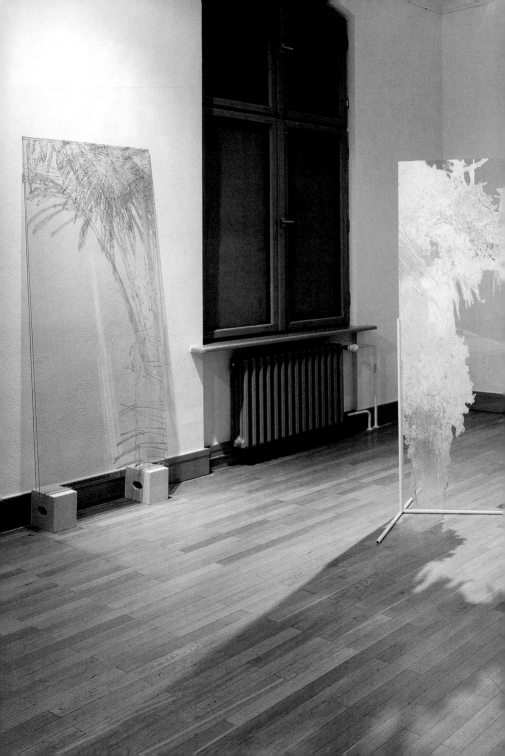

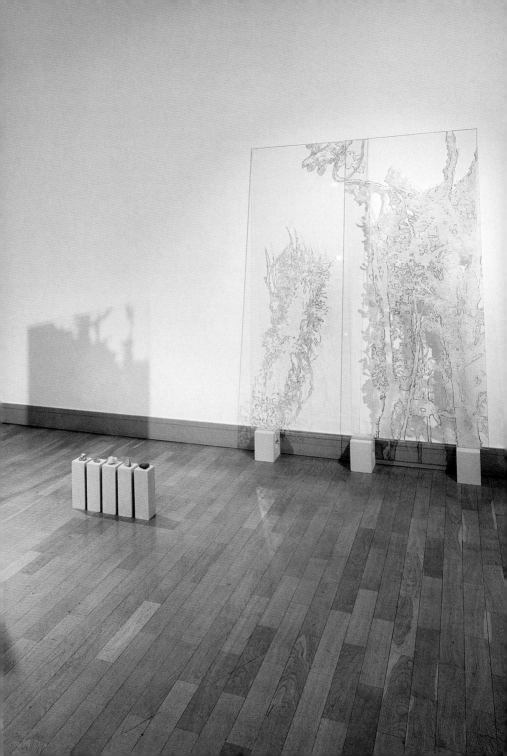

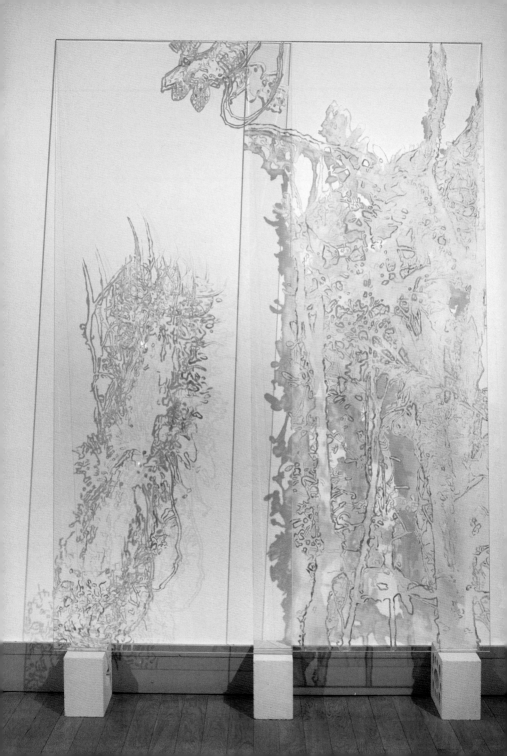

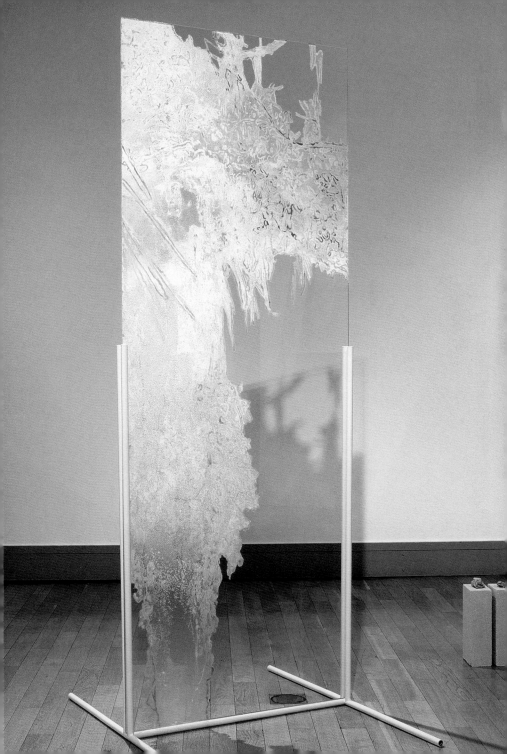

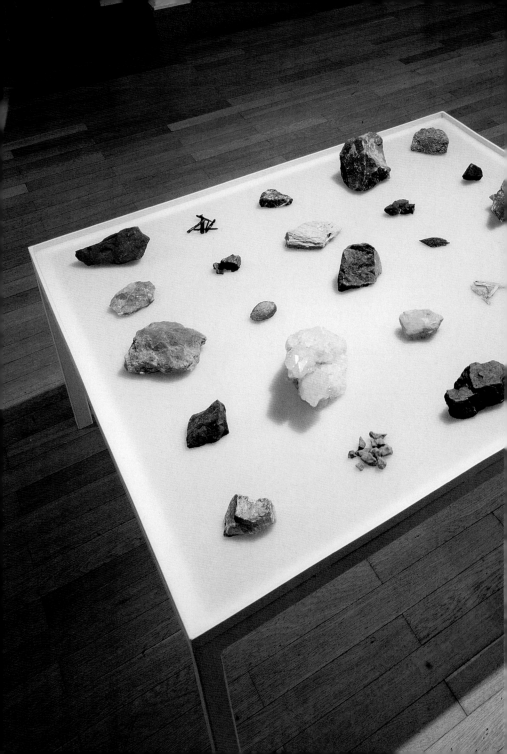

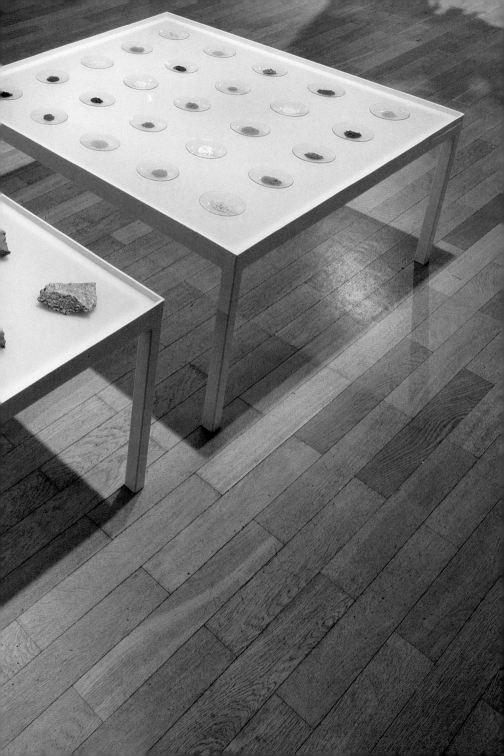

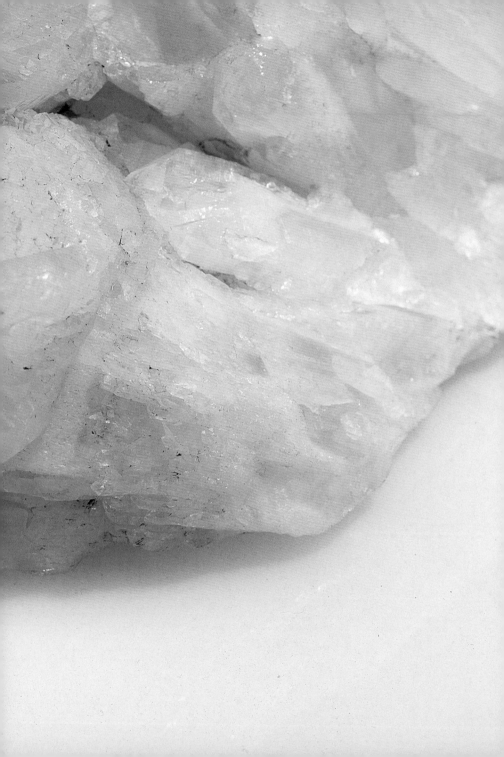

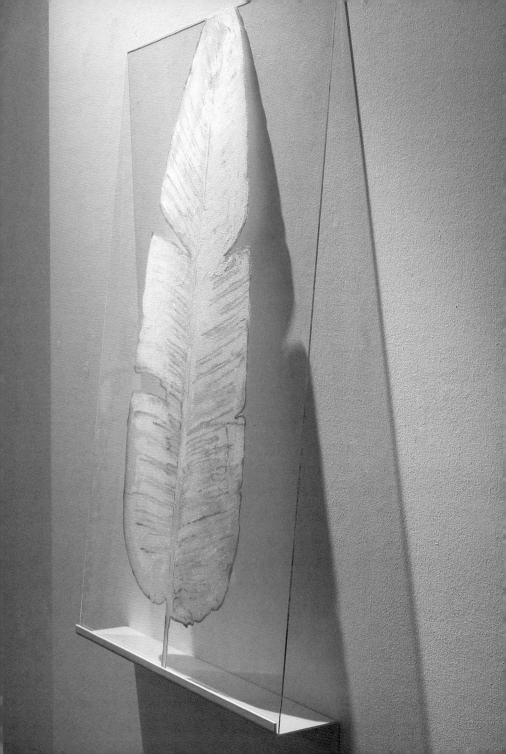

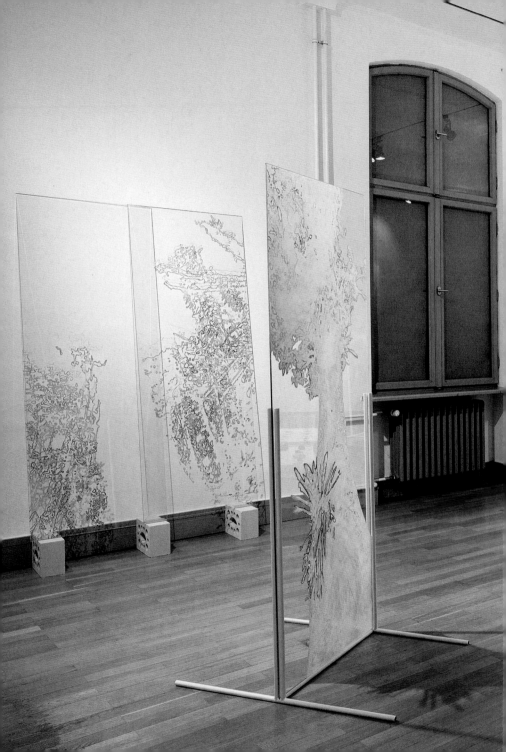

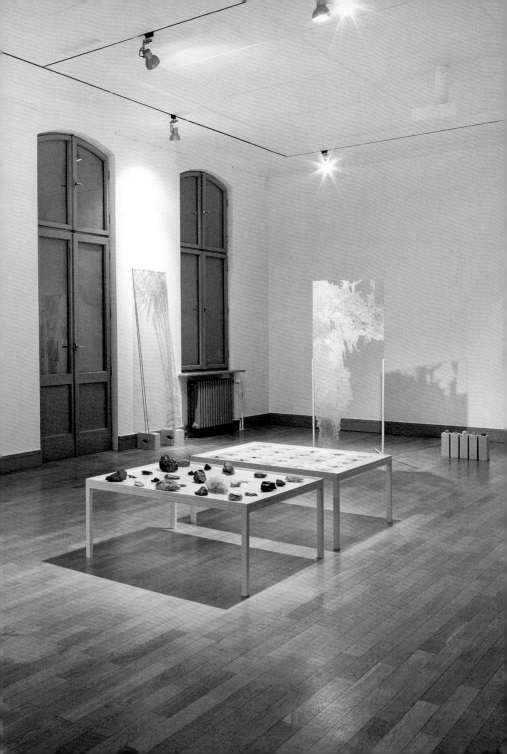

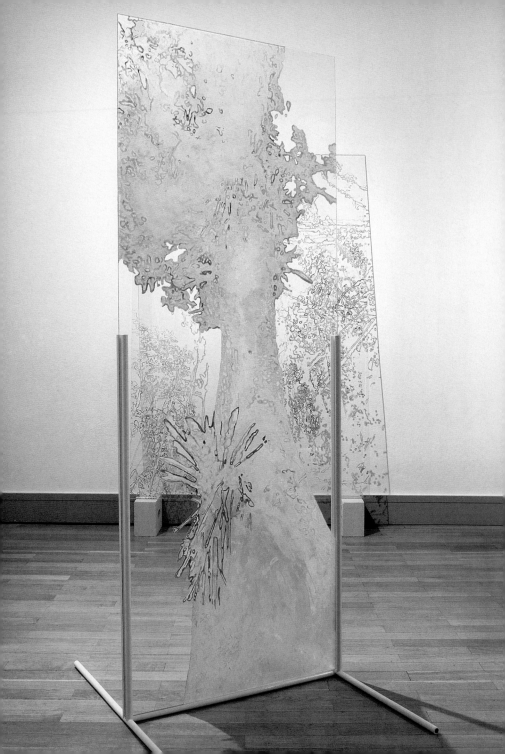

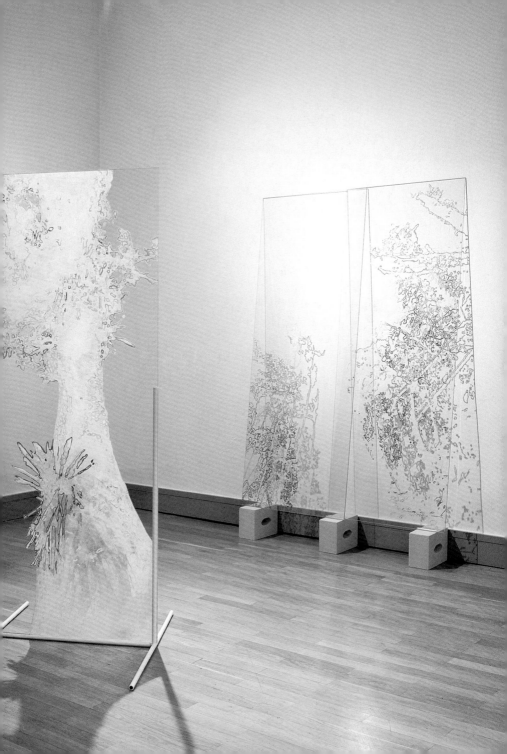

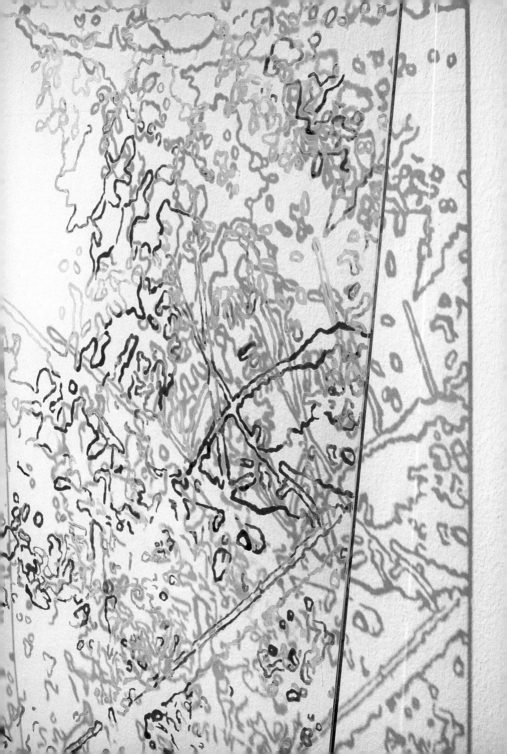

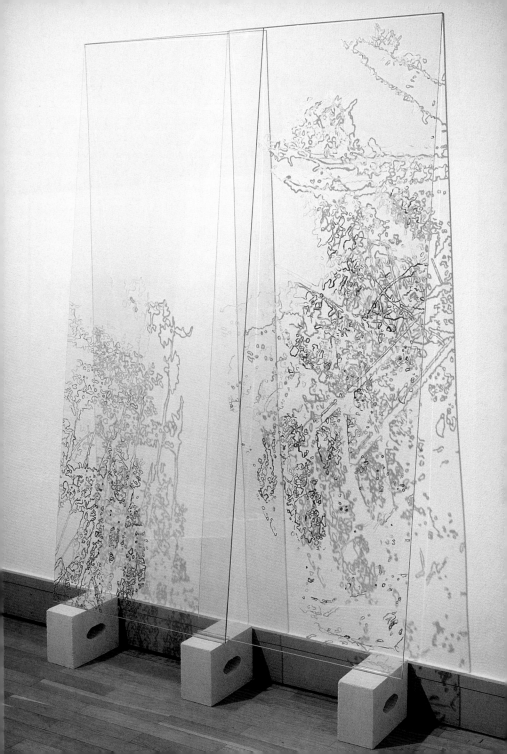

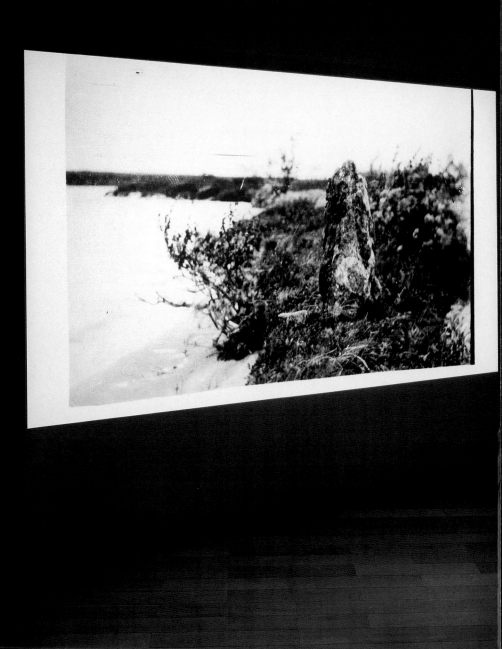

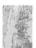
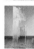

**Stories Told by Stones
(Late Paleozoic Era)**
Stein- und Erdpigmente
(insbesondere Alba Albula,
gelber Ocker, Quarz, Thulit,
roter Ocker) und
Alaunkristall auf Glas
2018, Dimensionen variabel
(fünf Glasscheiben à
180×70 cm)
*Stories Told by Stones
(Late Paleozoic Era)*
Stone and earth pigments
(especially alba albula, yellow
ochre, quartz, thulite, red ochre)
and alum crystal on glass
2018, dimensions variable (five
glass sheets, each 180×70 cm)

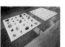

**Stories Told by Stones
(The Narrators)**
Mineralsteine, Erden,
daraus gemahlene Pigmente,
Laborgläser
2018, Zwei Tische,
je 45×100×100 cm
*Stories Told by Stones
(The Narrators)*
Mineral stones, earths,
pigments ground from them,
laboratory glasses
2018, two tables, each
45×100×100 cm

**Stories Told by Stones
(Plant Fossil)**

Stein- und Erdpigmente,
Alaunkristall auf Glas
2018, 61×97 cm
*Stories Told by Stones
(Plant Fossil)*
Stone and earth pigments,
alum crystal on glass
2018, 61×97 cm

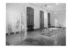

Ausstellungsansicht:
Schwartzsche Villa, Berlin, 2019
Exhibition view: Schwartzsche
Villa, Berlin, 2019

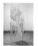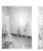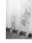

**Stories Told by Stones
(Lepidodendron)**
Stein- und Erdpigmente (ins-
besondere Lapislazuli, Quarz,
Sodalith, Alba Albula, Malachit)
und Alaunkristall auf Glas
2018, Dimensionen variabel
(drei Glasscheiben à
180×70 cm)
*Stories Told by Stones
(Lepidodendron)*
Stone and earth pigments
(especially lapis lazuli, quartz,
sodalite, alba albula, malachite)
and alum crystal on glass
2018, dimensions variable
(three glass sheets, each
180×70 cm)

Kivijumalia (Stone Gods)
HD video, Scheinwerfer
2019, Dauer 10:23
Kivijumalia (Stone Gods)
HD video, spotlights
2019, duration 10:23

Stories Told by Stones /
Dank an:
Technische Unterstützung /
Steinpigmente: Kremer
Pigmente, Aichstetten
Thematische Beratung /
Geologie: Saija Saarni,
Doktorand in Geologie,
Universität Turku, Finnland
Thematische Beratung /
Animismus: Graham Harvey,
Professor für Religionswissen-
schaft, Großbritannien
Stories Told by Stones / Thanks:
Technical support / stone
pigments: Kremer Pigmente,
Aichstetten
Thematic consultancy / geology:
Saija Saarni, Ph.D. Researcher
in Geology, University of Turku,
Finland
Thematic consultancy / animism:
Graham Harvey, Professor of
Religious Studies, UK

Kivijumalia (Stone Gods) /
Dank an:
Zusammenarbeit / Musik: Islaja
Thematische Beratung /
Heilige Steine: Das Archiv der
Finnischen Literaturgesellschaft
und der Finnischen Agentur
für Kulturerbe
Thematische Beratung / Sami-
Perspektive: Aslak Holmberg,
Samisches Parlament, Vorsitzen-
der des Kulturausschusses und
Lada Suomenrinne
Kivijumalia (Stone Gods) /
Thanks:
Collaboration / music: Islaja
Thematic consultancy / sacred
stones: The Archive of the
Finnish Literature Society and
The Finnish Heritage Agency
Thematic consultancy / Sámi
perspective: Aslak Holmberg,
Sámi Parliament, Chair of the
Cultural Committee and Lada
Suomenrinne

Elsa Salonens *Stories Told by Stones:*

Wenn Steine Geschichten erzählen

oder

Die Wirkkraft der belebten Natur

Christine Nippe

"Meine Arbeiten verbinden spirituelle Dimensionen mit wissenschaftlichen Wahrheiten, die unsere Grundannahmen der Welt formen" (Elsa Salonen)[1]

Die in Finnland geborene und in Bologna und Berlin ausgebildete Künstlerin Elsa Salonen untersucht in ihren Werken auf poetische Weise unser Verhältnis zur Umwelt. Indem sie das alte Wissen der Alchemie künstlerisch interpretiert, entstehen ihre Arbeiten. Salonen sammelt Blüten, extrahiert den Farbstoff und stellt aus ihnen bunte Kristalle her. Sie zeichnet mit fein zermahlenem Meteoritenstaub Sternenbilder auf Glas oder destilliert die Flüssigkeit aus Pflanzen. Und sie aktiviert verloren geglaubte Rituale sowie magische Praktiken in ihrer Kunst: „Ein Stein, ein Fuchsknochen oder eine Rose teilen ihre ganz besondere Weisheit mit uns," so Salonen während unserer Ausstellungsvorbereitungen im Gespräch.[2] Mit ihrer Kunst lädt sie die Betrachtenden ein, den Blick auf die Natur zu richten, innezuhalten und ihren Erzählungen zu folgen.

Ihre Werkreihe *Stories Told by Stones* (2018/2019) geht diesen Weg. Sie stellt das Bewusstsein der Steine und die in ihnen gespeicherte Tiefenzeit ins Zentrum der Aufmerksamkeit. Von Geologie, Alchemie und Animismus inspiriert, sammelt Salonen Geschichten von Mineralien, Kristallen und Steinen. Denn als älteste Bewohner der Erde haben sie, diesen Ansätzen folgend, die unterschiedlichen Zeiten gespeichert.

Einer der wichtigsten Hintergründe ist die Idee des Animismus, der davon ausgeht, dass alles aus der Natur beseelt sei oder in ihr ein spirituelles Bewusstsein wohne. Elsa Salonen bezieht sich auf die Lesart des britischen Religionswissenschaftlers Graham Harvey, der unsere Beziehung zu unseren „Nachbarn" erforscht, wie beispielsweise „Tieren, Pflanzen, Felsen oder Wasserkochern" und Respekt zu ihnen einfordert.[3] Sie alle besäßen eine Relevanz für uns. Denn der Begriff „Person" umfasse

mehr als das geläufige Verständnis, dass nur der Mensch im Zentrum der Schöpfung stehe, so Harvey.[4] Dieses Konzept macht eine neue Lesart auf und stellt die Natur als genauso wertvoll wie den Menschen dar. Und es geht noch weiter: Die Menschheit kann von dem Gedächtnis der Steine, Amöben oder anderer Urformen lernen. Harveys Interesse an Glauben, Lokalität und Ökologie verschmilzt mit seinem Fokus auf Kulturen indigener Völker in Neuseeland, Australien, Hawaii, den Ojibwe-Gebieten Nordamerikas oder den Samen in Fennoskandinavien. Ebenso interessiert er sich für viele aktuelle Communities wie Umweltaktivisten, Ökofeministen oder Science-Fiction-Fans.

Das aktuelle Interesse am Konzept des Animismus wie beispielsweise in der von Anselm Franke für das Haus der Kulturen der Welt entwickelten Ausstellung *Animism* (2012) oder der im Hamburger Bahnhof – Museum für Gegenwart von der Künstlerin Antje Majewski konzipierten Schau *How to talk with birds, trees, fish, shells, snakes, bulls and lions* (2018) kann als Reaktion auf den nun nicht mehr zu ignorierenden Wandel unserer Natur und als Suche nach neuen Wissensformen gelesen werden. Die zeitgenössische Kunst bildet einen Möglichkeitsraum, um andere Informationen und Imaginationen in das heutige Bewusstsein zu rücken und Raum für Alternativen zu eröffnen.

Genau in diesem Möglichkeitsfeld bewegt sich auch Elsa Salonen mit ihrer künstlerischen Praxis. Ihre Serie besteht aus neu produzierten und eigens für die Galerie der Schwartzschen Villa entwickelten Arbeiten. Die Bestandteile des Projektes sind ganz im Sinne ihres Herstellungs- und Rechercheprozesses eine Mineraliensammlung, natürliche Stein-Pigmente, Landschaftsgemälde auf Glas sowie eine Projektion mit historischen Fotografien heiliger Steine. Während im großen Galerieraum auf menschengroßen Glasscheiben in Form von Naturdarstellungen Fragen zur Geologie und Alchemie aufgeworfen werden, stehen im zweiten traditionelle Glaubensformen und Rituale im Mittelpunkt.

Im großen Raum zeigt Salonen unter dem Titel *Stories Told by Stones (Late Paleozoic Era)* mehrere große in Gelb und Rosé gehaltene Naturdarstellungen auf Glas. Sie changieren zwischen Abstraktion und Figuration. So imitieren sie die kristalline Oberfläche der Steine sowie exotisch anmutende Pflanzen und erinnern an frühere, prähistorische Zeiten.

Basis aller Malereien sind aus Mineralien und Steinen hergestellte Naturpigmente eines deutschen Herstellers oder der Künstlerin selbst. Grundlage für die Gewinnung solcher Pigmente ist die Alchemie als alter Zweig der Naturphilosophie des 1. und 2. Jahrhunderts. Sie beschäftigt sich mit der Reaktion von Stoffen. Salonen wendet dieses Wissen an, indem sie

auf den 70×180 cm großen Glasscheiben Oberflächenstrukturen der Steine und Pflanzen minutiös aufträgt. Es werden auch Kunstwerke mit Blättern im Raum platziert, sodass das Licht Schatten von ihnen auf die Wände wirft und eine besondere Atmosphäre entsteht.

Schließlich bezieht sich die Werkgruppe *Stories Told by Stones (Lepidondendron)* auf an Bäume erinnernde Malereien, die vorrangig in Lapislazuli-Blau und Malachit-Grün, Bergkristall-Weiß, dem cremefarbenen Alba Albula-Stein sowie rot-bräunlichem Ocker gezeichnet wurden. Eine kleinere Glasmalerei mit einem Bananenbaumblatt bildet eine weitere Referenz an eine andere Zeit, als unsere Kontinente noch in anderen Formationen existierten. Farne und Urwaldgewächse überwucherten den Norden und es gab eine Flora und Fauna, die wir heute mit anderen Gefilden assoziieren. Die Steine aus Salonens Sammlung sind wie ein Reigen farbiger Verweise und als Träger des Tiefengedächtnisses vor den Malereien platziert.

Betritt man schließlich den kleineren Raum, tritt das Mystisch-Spirituelle in den Vordergrund. Denn seit der vorchristlichen Ära gibt es im Norden die heidnische Tradition, Findlinge oder große Steine zu verehren. Es besteht das Ritual der Heiligsprechung. Elsa Salonen ist bei ihren Recherchen in der Finnish Literature Society auf Fotografien und Texte zu heiligen Steinen

gestoßen. Ausgehend von ihren Recherchen dort hat sich die Künstlerin mit verschiedenen Ritualen rund um spirituelle Steinformationen beschäftigt. So sind in ihrer Projektion Aufnahmen von auf den ersten Blick zerlöcherten Felsen zu sehen. Diese stehen in der heidnischen Tradition und dienen mit ihren Aushöhlungen als Behältnis für kleine Gaben für den Geist des Steins. Dahingegen ist die Bandbreite der Steinverehrung bei den Samen besonders interessant. Denn hier suchten Fischer, Jäger und Rentierhirten ihren jeweiligen heiligen Stein auf, um Glück für ihre Arbeit zu erbitten.

Elsa Salonen verweist uns damit auf das heutige, menschengemachte Zeitalter des Anthropozäns und erinnert an die vorchristliche Ära, in der große Findlinge als Träger spiritueller Kräfte verehrt wurden und ihr Wissen um ihr Tiefengedächtnis von vielen verschiedenen Kulturen anerkannt war. Sei es Stonehenge in der Nähe des heutigen Salisbury in England, die 40 Meter hohen Externsteine im Teutoburger Wald als Kultstätte der Germanen oder der Gollenstein bei Blieskastel im Saarland. Es gibt viele Formen von magischen Orten, in deren Zentrum große Steine stehen.

Das Projekt *Stories Told by Stones* (2018/2019) ist durch viele Gespräche zwischen Elsa Salonen und mir geprägt. Ausstellung, Rahmenprogramm und Buch entstehen in einem gemeinsamen Prozess des Austauschs. Das Besondere für mich liegt in ihrem Ansatz, immer

wieder innezuhalten. Es benötigt gerade in Zeiten des Klimawandels und der radikalen Ausbeutung von Bodenschätzen solch eine Aktivierung vergessener Rituale. Die Künstlerin möchte auf die Weisheit und die Rechte der Steine sowie der Natur im Allgemeinen verweisen. Damit teilt sie das Interesse und die Frage, inwieweit auch unbelebte Dinge wie Pflanzen, Insekten oder Steine unser Handeln beeinflussen mit einem der großen französischen Soziologen, nämlich Bruno Latour. Der Theoretiker entwickelte mit seiner Actor-Network-Theory einen bahnbrechenden Ansatz, der davon ausgeht, dass die uns umgebenden Dinge unser Handeln und Fühlen beeinflussen.[5]

Vielleicht möchte die Künstlerin uns an Folgendes erinnern: Glaubt wieder an die Dinge, die ihr nicht versteht, wendet euch alten und neu interpretierten magischen Praktiken zu.

Ihr Ansatz des Animismus steht für die Integration der Natur in unser Denken. So wie sie besinnen sich aktuell immer mehr Menschen auf die Umwelt und ihre Bestandteile aus Flora und Fauna, Menschen und Steine. Es geht schließlich um die Rückbesinnung auf Traditionen sowie ihre Neuinterpretation, um Achtsamkeit und um eine Aktualisierung lebensreformatorischer Ideen. Dazu gehört, alte genauso wie neue Imaginationen zu aktivieren. Dies können indigene, vormoderne, postmoderne oder der globalisierten Welt sein. Solch ein Weg ist bei Salonen eng mit ihrer Liebe zu den zuvor beschriebenen Ideen verknüpft, da „ein Stein, ein Fuchsknochen oder eine Rose ihre ganze besondere Weisheit mit uns teilen" und bei ihr gilt: „Meine Arbeiten verbinden spirituelle Dimensionen mit wissenschaftlichen Wahrheiten, die unsere Grundannahmen der Welt formen."

1 Elsa Salonen im Gespräch mit Christine Nippe im November und Dezember 2018.
2 Ebd.
3 Siehe Graham Harvey, *Animism: Respecting the Living World*, second edition, 2017.

4 Siehe Graham Harvey, *Animism: Respecting the Living World*, second edition, 2017.
5 Bruno Latour beschreibt in seinem Buch *Reassembling the Social. An Introduction to Actor-Network-Theory* (Oxford

University Press, 2005), wie Dinge unsere Verhaltensweisen beeinflussen: die Form einer Tür kann beispielsweise einen Einfluss darauf haben, wie wir durch sie hindurchgehen.

Elsa Salonen's *Stories Told by Stones:*

When Stones Tell Stories

or:

The Power of an Animate Nature

Christine Nippe

"My works connect spiritual dimensions to those scientific truths that form our basic concepts of the world."
(Elsa Salonen)[1]

Artist Elsa Salonen, who was born in Finland and trained in Bologna and Berlin, uses her works to examine our relationship to the environment in a poetic manner. These pieces emerge out of her artistic interpretation of ancient alchemical knowledge. Salonen gathers flowers, extracts their pigment, and makes colorful crystals out of them. She uses finely ground meteorite dust to draw images of stars on glass or distills fluids out of plants. In her art, she also activates rituals and magic practices once believed to have been lost: "A stone, a fox bone or a rose all have particular wisdom to share," as she said during a conversation while we were preparing for the exhibition.[2] With her art, she invites viewers to turn their gaze to nature, to take time to pause and listen to its stories.

Her series *Stories Told by Stones* (2018/2019) pursues this path. It focuses attention on the consciousness of the stones and the deep time stored inside them. Inspired by geology, alchemy, and animism, Salonen collects stories from minerals, crystals, and stones: All these perspectives hold that these materials, as the earth's oldest inhabitants, have stored the earth's different ages within themselves.

One of the most important contexts behind her work is the idea of animism, which is based on the assumption that everything in nature has a soul or that a spiritual consciousness resides inside it. Salonen makes reference to the interpretation of the British religious scholar Graham Harvey, who researches our relationship with our neighbors, such as "animals, plants, rocks and kettles," and demands that we show them respect.[3] All of them are of relevance for us because, according to Harvey, the notion of "person" encompasses more than

the usual understanding of the word, in which humans stand alone at the center of creation.[4] This concept opens up a new interpretation and presents nature as just as valuable as people. And its goes even further: The human species can learn from the memory of stones, amoebas, or other primal forms. Harvey's interest in beliefs, locality, and ecology merges with his focus on the cultures of indigenous peoples in New Zealand, Australia, Hawaii, the Ojibwe regions of North America or the Sámi on the Fennoscandian Peninsula. He is equally interested in many contemporary communities, such as environmental activists, ecofeminists, or science-fiction fans.

The current interest in the concept of animism—for example, at the 2012 exhibition *Animism*, developed by Anselm Franke for Berlin's Haus der Kulturen der Welt, or the 2018 show *How to talk with birds, trees, fish, shells, snakes, bulls and lions*, which was conceived for Berlin's Hamburger Bahnhof—Museum für Gegenwart by the artist Antje Majewski—can be interpreted as a reaction to the now unmistakable changes in our natural world as well as the search for new forms of knowledge. Contemporary art establishes a realm of possibility within which we can shift other information and imaginations into our current consciousness and open up space for alternatives.

Salonen uses her artistic practice to operate within precisely this field of possibilities. Her series consists of new works created specifically for the gallery of the Schwartzsche Villa. Entirely in keeping with her process of production and research, the elements making up her project are a collection of minerals, natural stone pigments, and landscape paintings on glass as well as a projection featuring historical photographs of sacred stones. While questions about geology and alchemy are raised in the form of representations of nature on human-sized sheets of glass in the large exhibition gallery, the main focus in the second gallery is on traditional forms of belief and rituals.

In the large space, Salonen presents several large representations of nature painted in yellow and light pink on glass that are entitled *Stories Told by Stones (Late Paleozoic Era)*. These works oscillate between abstraction and figuration, imitating the crystalline surface of stones as well as exotic-looking plants and recalling earlier, prehistoric times.

Natural pigments produced from minerals and stones by a German manufacturer or the artist herself provide the foundation of all the paintings. Alchemy furnishes the basis for gaining pigments of this kind: This ancient branch of first- and second-century natural philosophy deals with the reactions of materials. Salonen utilizes this knowledge by meticulously applying the surface structures of stones and plants to the 70×180 cm sheets of glass. Artworks featuring leaves are also placed in this room in such a way that

the light casts their shadows onto the walls, producing a distinctive atmosphere.

Finally, the group of works entitled *Stories Told by Stones (Lepidondendron)* tells its tale with paintings reminiscent of trees and delineated primarily in lapis-lazuli blue and malachite green, rock-crystal white, cream-colored Alba Albula rock, and reddish-brown ocher. A smaller painting on glass featuring a banana-tree leaf develops an additional reference to another time when our continents still existed in other formations. The North was overgrown with ferns and jungle plants, and it had a flora and fauna we now associate with other regions. The stones from Salonen's collection are placed in front of the paintings like a choreographed round of chromatic allusions and as vessels of deep memory.

When we finally enter the smaller space, the mystical-spiritual aspect becomes the most prominent. In the North, there have been pagan traditions of venerating erratic rocks or large stones since the pre-Christian era. A consecration ritual existed. During her research at the Finnish Literature Society, Salonen came across photographs and texts related to sacred stones. Based on her research there, the artist has occupied herself with various rituals surrounding spiritual stone formations. Thus, in her projections, we find images of rocks that, at first glance, appear to have been perforated with holes. These stand in the pagan tradition and, with their hollows, served as receptacles for small votive offerings to the spirit of the stone. By contrast, the broad range of stone veneration among the Sámi is particularly interesting: Here fishermen, hunters, and reindeer herdsmen sought out the stone sacred to each of them in order to plea for good fortune in their work.

Salonen thus directs our attention to the present, human-made epoch of the Anthropocene and reminds us of the pre-Christian era, in which large erratic stones were venerated as vessels of spiritual forces and the knowledge of their deep memory was recognized by many different cultures. Whether Stonehenge, near the modern English town of Salisbury, the forty-meter-tall Externsteine in the Teutoburg Forest, which were a Germanic cult site, or the Gollenstein, near the town of Blieskastel in Germany's Saarland: There are many forms of magical places centered around large stones.

The project *Stories Told by Stones* (2018/2019) was shaped by numerous conversations between Salonen and myself. The exhibition, program of events, and book were created in a joint process of dialogue. For me, they are distinguished by their approach of repeatedly taking time to pause. Activating forgotten rituals like this is particularly necessary in this period of climate change and radical exploitation of the natural resources resting within the earth. The artist seeks to point out the wisdom and the rights of stones as well as nature in general.

She thus shares an interest and a question with the great French sociologist Bruno Latour: To what extent do insentient things like plants, insects, or stones influence our activity? With his actor-network theory, this theorist has developed a pioneering approach based on the premise that the things surrounding us influence our activity and feelings.[5] Perhaps the artist would like to remind us to do the following: Believe again in the things you do not understand and turn to ancient and reinterpreted magical practices.

Salonen's animist approach represents the integration of nature into our thinking. Like her, more and more people are currently reflecting on the environment and its elements of flora and fauna, humans and stones. This is ultimately about the reflective recollection of past traditions as well as their reinterpretation, mindfulness, and a modernization of twentieth-century concepts for reforming the way we live. It also involves activating both ancient and new imaginations. These can come from an indigenous, premodern, postmodern, or globalized world. In Salonen's case, this kind of path is intimately linked with her love for the ideas already described here, because "a stone, a fox bone or a rose all have particular wisdom to share," and for her: "My works connect spiritual dimensions to those scientific truths that form our basic concepts of the world."

1 Elsa Salonen in conversation with Christine Nippe during November and December of 2018.

2 Ibid.

3 See Graham Harvey, *Animism: Respecting the Living World*, 2nd ed. (London: C. Hurst, 2017).

4 See Ibid.

5 In his essay "Reassembling the Social. An Introduction to Actor-Network-Theory," Bruno Latour describes how the way in which a door is constructed influences our behavior as we pass through it.

Wie viel Bewusstsein eines Steins bleibt im Pigment eines Azurites übrig?

Elsa Salonen

Die aktuelle anthropozäne Ära hat uns gezwungen, unsere Position auf der Erde zu überdenken. Die anhaltende Klimakrise könnte die Illusion erweckt haben, dass wir aufgrund des völligen Fehlens gesunder Ideologien in diese schwierige Situation geraten sind. Doch Weisheit, die unsere jenseits der Menschheit liegenden Nachbarn anerkennt und respektiert, existiert seit Jahrtausenden und gedeiht auch in der Gegenwart. Nach der alten, aber aktiven Weltanschauung des Animismus ist jede einzelne Pflanze, jeder einzelne Felsen, jeder einzelne Baum und jedes einzelne Tier eine bewusste Einheit und stellt eine aktive Beziehung zu anderen her.

Unter allen bewussten Wesen sind Steine als die ältesten Bewohner unseres Planeten diejenigen, die die meisten der verschiedenen Momente der sich ständig verändernden Geschichte der Erde erlebt haben. Tatsächlich ist es vor allem den Steinen zu verdanken, dass wir wissen, was wir über die geologische Geschichte der Welt wissen. Indem sie lernten, die Zeichen der Felsen zu „übersetzen", konnten die Geologen das Alter der Erde, ihre vergangenen

Klimazonen und sogar die Evolutionsgeschichte des Lebens im Allgemeinen simulieren.

Die bemerkenswerte Weisheit der Steine wurde in meinem Heimatland Finnland vor der christlichen Ära auf sehr konkrete Weise anerkannt: Große unregelmäßige Felsen wurden mit immensem Respekt verehrt: Die Macht der alten Steine und damit die gegenseitige Abhängigkeit von allem wurde durch Opfergaben anerkannt, um zum Beispiel einen guten Ertrag im Fischen oder der Jagd zu erwirken.

Eine Mineraliensammlung und daraus gemahlene Pigmente bildeten den Ausgangspunkt für meine Ausstellung *Stories Told by Stones* in der Schwartzschen Villa in Berlin. Ich habe Visionen von prähistorischen Landschaften auf Glas gemalt und dabei Pigmente von Steinen verwendet, die bereits in den dargestellten Epochen existierten. Mit einem animistischen Blick verändert sich das Bild der natürlichen Pigmente radikal. In den Gemälden mit Steinpigmenten sind die Steine die Erzähler.

Wie viel Bewusstsein eines Steins bleibt in einem Pigment aus einem Azurit übrig?

Graham Harvey, Professor für Religionswissenschaft, definiert es wie folgt:

„Es ist typisch für animistische Lebenswege, dass die Transformation lebender Personen von Bäumen zu Artefakten nicht als Zerstörung von Leben und Menschlichkeit oder deren konsequente Transformation zur Künstlichkeit erlebt wird. Menschliche Artefakte bereichern nicht

nur die Begegnung zwischen Personen, sondern werden oft selbst als autonome Akteure erlebt. In der Kunst drücken sich nicht nur die Menschen aus, sondern auch die Personen, die transformiert sind."

(*Animism: Respecting the Living World*, 2006, S. 56–57)

Natürlich bleibt der Begriff des Bewusstseins von einer Spezies zur anderen nicht unverändert: Mit kleinen Schritten erkennt die Wissenschaft das Bewusstsein vom Nicht-Menschlichen an. Zuerst Tiere, jetzt geht es in der Debatte um das Pflanzen-bewusstsein. Werden zukünftige Generationen auch Studien über das Steinbewusstsein erleben?

How much of a stone's consciousness is left in a pigment ground from an azurite?

Elsa Salonen

The current Anthropocene era has forced us to re-think our position on Earth. The ongoing climate crisis might create an illusion that we have ended up in this troublesome situation because of the total lack of healthy ideologies. However, wisdom that recognizes and respects our other-than-human neighbors has existed for thousands of years and continue to thrive in the present. According to the ancient — yet active — worldview, animism, every single plant, rock, tree or animal is a conscious entity and an active relation of others.

Among all of the conscious beings, stones — as one of the oldest inhabitants of our planet — are the ones that have witnessed most of the various scenes of the Earth's continuously transforming history. As a matter of fact, it is mainly due to the stones that we know what we know about the geological history of the world. By learning to 'translate the signs' of the rocks, geologists have been able to demonstrate the age of the Earth, its past climates and even the evolutionary history of the life in general.

The remarkable wisdom of stones was acknowledged in a very concrete way in my home country, Finland, before the Christian era: large, irregular rocks were worshipped with great respect. The might of ancient stones, and in the process the interdependence of everything, was taken into account by offerings for the sacred stones to bring, for example, good fishing or hunting fortune.

A mineral stone collection and the pigments ground from them worked as the starting point for my exhibition *Stories Told by Stones* at Schwartzsche Villa, Berlin. I have painted visions of prehistoric landscapes on glass, using pigments from stones that already existed during the depicted eras. With an animist view the image of the natural pigments changes radically. In the paintings made with stone pigments, the stones are the narrators.

How much consciousness of a stone is left in a pigment ground from an azurite?

As Graham Harvey, Professor of Religious Studies defines it:

"It is typical of animist lifeways that the transformation of living persons from trees to 'artefacts' is not experienced as a destruction of life and personhood, nor their consequent transformation to artificiality. Human artefacts not only enrich the encounter between persons, but are often themselves experienced as autonomous agents. In art not only do humans express themselves, so too do those persons who are transformed."

(*Animism: Respecting the Living World*, 2006, pp.56–57)

Needless to say, the notion of consciousness doesn't remain unchanged from one species to another: with small steps, science is recognising the consciousness of other-than-humans. First it was animals, now the debate is about plant consciousness. Will future generations witness studies about stone consciousness too?

Interview zwischen
Laura Hirvi und Elsa Salonen

LH

Du wohnst nun circa zehn Jahre lang in Berlin. Wie ist das, als Künstlerin in solch einer Metropole zu leben?

ES

Ich liebe Berlin einfach wegen seiner Multikulturalität. Durch meine internationale Familie hier in Berlin lerne ich ständig neue Sichtweisen kennen. Eines der wichtigsten Gefühle in meinem Leben ist folgendes: Mir wird klar, dass etwas, das ich als „normal" angesehen hatte, überhaupt nicht normal ist, da die Gepflogenheiten einer anderen Kultur genau das Gegenteil bedeuten. Manchmal zähle ich abends durch, wie viele Sprachen ich gesprochen und mit wievielen Ländern und Kontinenten ich während des Tages zu tun hatte. Dann fühle ich mich überglücklich und bereichert. Auch für mein künstlerisches Schaffen sind das schließlich unbezahlbare Erfahrungen.

LH

Fast während der gesamten Dauer deiner künstlerischen Tätigkeit hast du Materialien aus der Natur genutzt. Was ist daran so inspirierend und faszinierend für dich?

ES

Jedes der Materialien hat eine eigene Geschichte zu erzählen; ursprünglich brachte mich die Alchemie darauf, mit ihnen zu experimentieren. Ich destilliere den Farbstoff aus Blumen, verarbeite ihn weiter und bleiche die Pflanzen vollständig aus, bis sie

ganz weiß sind. Außerdem stelle ich aus bestimmten in der Natur vorkommenden Materialien – von Meteoriten bis Vulkanasche – eigene Pigmente her, je nach den Anforderungen, die sich aus dem künstlerischen Konzept jedes einzelnen Werkes ergeben. Fast alle Organismen stammen ja, wie man weiß, ursprünglich von uralten toten Sternen ab. Diese Theorie hat mich inspiriert, einzig unter Verwendung von Stein- und Eisenmeteoritenstaub eine Reihe von Sternbildern auf Glas zu malen.

Wenn man sich mit den individuellen technischen Anforderungen verschiedener natürlicher Materialien beschäftigt, untersucht man auch die spezifischen Lehren und Philosophien eines jeden: ein Stein, ein Fuchsknochen oder eine Rose teilen ihre ganz besondere Weisheit mit uns.

LH
Wie würdest du deine Beziehung zur Natur beschreiben, und welchen Einfluss hat die künstlerische Beschäftigung mit ihr ausgeübt?

ES
Auf die eine oder andere Weise beschäftige ich mich in den meisten meiner Arbeiten mit der Natur, insbesondere mit einer animistischen Weltsicht und dem damit verbundenen respektvollen Umgang mit dem „Nicht-Menschlichen". Als Kind hatte ich meinen ganz eigenen „heiligen" Felsen, auf dem ich saß, wenn ich Trost suchte, mein Herz ausschüttete oder grübelte. Ich habe auch einen heiligen Baum, den ich regelmäßig besuche. Ich habe auch bestimmte Gewohnheiten entwickelt: So frage ich den Wald um Erlaubnis, ob ich hineingehen darf, und vor jeder Mahlzeit danke ich den Quellen der Natur dafür, dass sie mir Energie spenden. Diese kleinen Gesten habe ich ganz von selbst entwickelt, ohne

Referenz zum Animismus – dass es ein sehr emotionales Erlebnis für mich war, als ich zum ersten Mal Texten zum Animismus begegnete und die Verbindung spürte, kann man sich wohl vorstellen. In einer Stadt wie Berlin ist es nicht so einfach, eine Beziehung zur Natur aufrechtzuerhalten. Ich habe hier auch in einem Park meinen ganz persönlichen Baum, aber da immer Leute in der Nähe sind, kann ich nicht so einfach mit ihm „kommunizieren" – man würde ja für verrückt gehalten werden.

Alles in allem hat die Tätigkeit als Künstlerin mir Zeit gegeben, mich nacheinander auf verschiedene natürliche Materialien zu fokussieren und meine Beziehung zu ihnen zu vertiefen.

LH
In dieser Ausstellung arbeitest du mit Steinen. Warum ausgerechnet mit Steinen?

ES
Einige Jahre lang habe ich hauptsächlich mit Blumen gearbeitet, denen ich die Farbe entzogen und die ich gebleicht habe. Leider verbleichen aber die pflanzlichen Pigmente; sie halten nur wenige Jahre lang. Deshalb habe ich nach Pigmenten mit dauerhafter Farbbeständigkeit gesucht. Minerale waren eine der wichtigsten Quellen für historische Pigmente, die mehr als ein Jahrhundert überdauern. Sie bieten eine ganze Palette an Farben, von den dunkelblauen Lapislazuli-Tönen bis zum zarten Rosa des Thulits.

Konzeptionell ausgedrückt finde ich die Frage der Steine und des Bewusstseins faszinierend. Vor wenigen Jahren war ich in Berlin an der Organisation eines Mini-Symposiums zum Pflanzenbewusstsein beteiligt. Ich erinnere mich deutlich an die Unterhaltung mit einem unserer

Gastredner, einem Philosophen, der sich der Thematik des Bewusstseins und der Neurobiologie der Pflanzen verschrieben hatte. Er scherzte darüber, wie lange die Wissenschaftler gebraucht hätten, Tieren ein Bewusstsein zuzugestehen, während – wie er meinte – die Öffentlichkeit die Intelligenz von Hunden beispielsweise schon eingeräumt habe. Er prophezeite eine ähnlich lang andauernde Debatte bezüglich der Pflanzen. Als ich dann die Steine ins Gespräch brachte, war selbst er, der erklärte Pionier des Bewusstseins der Pflanzen, überrascht, ja sogar abgeneigt. In meinen Augen zeigte er das gleiche Zögern wie die Wissenschaftler, die er gerade dessen bezichtigt hatte.

Ich finde die Frage eines Bewusstseins der Steine wirklich inspirierend, fesselnd und provokant!

LH
In der spirituellen Praxis der Sámi spielen Steine in Form der „seita" eine wichtige Rolle. Hat diese Tradition deine aktuelle Arbeit beeinflusst? Und besteht die Gefahr, von den Sámi der kulturellen Aneignung beschuldigt zu werden?

ES
Der Haupt-Ausstellungsraum in der Schwartzschen Villa widmet sich meinen Untersuchungen von Steinen, basierend auf Wissenschaft, Geologie und tiefer Zeit. Der kleinere Raum umfasst eher einen holistischen Ansatz, da geht es um die spirituellen Traditionen, die mit den Steinen verbunden sind. In Finnland wurden große, ungewöhnlich geformte Steine – uhrikivet – angebetet, um göttliche Gunst zu erlangen. Beispielsweise versprach man einem Stein Beeren, um eine gute Ernte abzusichern. Bei den Sámi gab es ähnliche

Traditionen mit ihren heiligen Steinen –
den seidat. Die Sámi brachten ihnen Opfer,
um bei der Fischerei oder der Jagd gute
Ergebnisse zu erzielen oder ihre Rentier-
herden sicher zu bewahren.

Das Archiv der Finnischen Literatur-
gesellschaft war meine hauptsächliche
Materialquelle. Es verfügt über eine seltene
Sammlung einschlägiger alter Fotos und
Interviews, sowohl zu den finnischen als
auch zu den Sámi-Traditionen. Ich hatte
gehofft, Archivmaterial beider Traditionen
in die Installation einfließen zu lassen, eine
ausgeglichene Perspektive zu schaffen.
Ich wollte dies aber nicht tun, ohne zuerst
die Sámi selbst kontaktiert zu haben. Nach-
dem ich zunächst mit einem samischen
Kollegen gesprochen und dann zu Aslak
Holmberg, dem Vorsitzenden des Kultur-
ausschusses im samischen Parlament,
Kontakt aufgenommen hatte, war deren
Reaktion darauf, dass ich die Dokumenta-
tion von "seidat" in die Arbeit integrieren
wollte, positiv. Als finnische Künstlerin
ist es wichtig, den Kontakt aufzubauen
und diesen Dialog zu führen. Das ist ein
wichtiger Prozess, um die Geschichte und
insbesondere unsere heutige Koexistenz
anzuerkennen.

Interview between
Laura Hirvi and Elsa Salonen

LH

You have been living in Berlin for about ten years now. What is it like living and doing art in a big urban space such as Berlin?

ES

I keep loving Berlin for its multiculture. I continually learn new points of view from my international Berlin family. One of my favourite feelings in life is when I realise that something that I've been taking as 'ordinary' turns out to not be ordinary at all because the customs of another culture reveals the opposite. Some evenings I count the number of languages I've used and the quantity of countries and continents I've been in contact with during the day and feel extremely lucky and rich to know such a varied group of people that I can call my loved ones. I think these are priceless lessons for making art as well.

LH

You have been working with natural materials for the majority of your professional life. What makes them so endlessly inspiring and fascinating?

ES

All of the natural materials have their own stories to tell and alchemy has led me to experiment with many of them. Now I distill colors from flowers, process the colors further and bleach plants to make them appear entirely white. I also prepare my own pigments from specific

natural materials—from meteorites to volcanic ash—according to the various conceptual requirements of each individual work. Almost all of the elements of living organisms are known to have originated from ancient, dead stars. Inspired by this scientific theory, I painted a series of constellations on glass using solely dust from stone and iron meteorites.

Learning the individual technical requirements of different natural materials is a way to explore the specific teachings and philosophies of each of them; a stone, a fox bone or a rose all have particular wisdom to share.

LH
How would you describe your relationship to nature and how has making art of it affected this relationship?

ES
In one way or another, most of my works deal with nature, especially the animist worldview and the respectful relationship it brings to the engagement with the other-than-human. As a child, I used to have my own sacred rock to sit on and to seek comfort from, cry my sorrows to or just share the questions that I was pondering upon. I have my own sacred tree in Finland which I visit regularly. I have developed habits like asking the forest for permission to enter or thanking nature's sources for providing me energy before each meal. I have developed these small animist gestures alone, without references—so you can imagine the emotion and sense of connection when first encountering texts about animism! In a city like Berlin, it's slightly harder to maintain this kind of relationship with nature. Here too, I do have my own special tree in a park, but it's not as simple to communicate with it, when there are always other people

LH
This time you are working with stones.
Why stones?

around—you would be taken for a lunatic. In general, making art has provided me time to focus on various natural materials one at a time, and deepen my relationship with each of them.

ES
For some years I worked mainly with flowers extracting their colors and bleaching them. Unfortunately, the vegetal pigments discolor, and only last for some years. So I started to look for pigments with more lasting properties. Mineral stones have been one of the most important sources for historical pigments and endure for more than a century. They offer a diverse palette of colors, from the deep blue tones of lapis lazuli to the delicate pink of thulite.

In more conceptual terms, I find the question about stones and consciousness fascinating. A few years back I co-organized a mini-symposium in Berlin about plant consciousness. I had a memorable conversation with one of our guest speakers, a philosopher dedicated to plant consciousness and plant neurobiology. He was joking about how slow scientists have been in granting consciousness to animals, while, according to him, the public had long been able to acknowledge, for example, dogs' intelligence. He predicted a similar, long-lasting debate about plants. When I brought up stones, even he—a pioneer of plant consciousness—was surprised and resistant. In my eyes, he showed the same slowness, which he just had accused some scientists about.

For me, the question of stones and consciousness is so inspiring and intriguing, as well as provocative!

LH

In the traditional Sámi spiritual practice stones play an important role in the form of 'seita'. Did this tradition influence your current work? Is there a risk of being accused by the Sámi for the act of cultural appropriation?

ES

The main exhibition space at the Schwartzsche Villa is dedicated to my research on stones, informed by science; geology and deep time. The smaller room takes on a more holistic approach, dealing with spiritual traditions linked to the stones. In Finland, large, irregular stones—uhrikivet—were worshipped, in order to incur divine favor. For example, berries were promised to a stone in order to ensure a good harvest. The Sámi had similar traditions with their sacred stones—seidat. The Sámi brought offerings to stones to ensure good fishing or hunting fortune or to keep reindeer herds safe.

My main source of material has been the Finnish Literature Society's archive. They have a rare collection of old photos and interviews related to these practices, from both Finnish and Sámi traditions. I hoped to be able to include some archive material from both traditions in the installation, offering a rounded perspective, but I wouldn't do so without first contacting Sámi people. So, having spoken with a Sámi colleague I contacted Aslak Holmberg, the chair of the Cultural Committee of the Sámi and their response was positive for including the documentation of 'seidat' in the work. As a Finnish artist, making contact and having dialogue is an important process in order to acknowledge the history and especially our co-existence today.

Zitate und Quellen
Quotes and source images

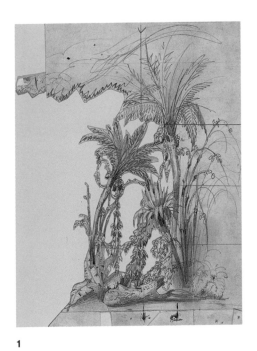

1

2

" 'Animism' is now an important term for describing ways in which some people understand and engage respectfully with the larger-than-human world. Its central theme is our relationship with our other-than-human neighbours, such as animals, plants, rocks, and kettles, rooted in the understanding that the term 'person' includes more than humans."

1 Eugène Cicéri, Entwurf für ein Bühnenbild in der Pariser Oper, Ende 19. Jahrhundert
Eugène Cicéri, Design for a stage set at the Paris Opera, Late 19th Century

2 Graham Harvey, *Animism: Respecting the Living World*, Second edition, 2017

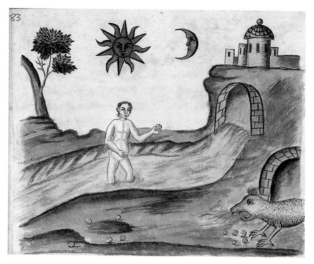

3

4

"(…) everything that lies in the belly of the earth is alive, albeit in the state of gestation. In other words, the ores extracted from the mines are in some way embryos: they grow slowly as though in obedience to some temporal rhythm other than that of vegetable or animal organisms. They nevertheless do grow – they 'grow ripe' in their telluric darkness. Their extraction from the bowels of the earth is thus an operation executed before its due time. (…) This bold conception, whereby man defends his full responsibility vis-à-vis Nature, already gives us a glimpse of something of the work of the alchemist. (…) For a similar reason, mines were allowed to rest after a period of active exploitation. The mine, matrix of the earth, required time in order to generate the new."

3 Unbekannter Autor, Clavis Artis, „Geheimschlüssel für viele okkulte Operationen im Tierreich, im Bereich der Metalle und Mineralien", Ende des 17. oder Anfang des 18. Jahrhunderts
Unknown author, Clavis Artis, "Secret key for many occult operation in the animal kingdom, in the realm of metals and minerals", late 17th or early 18th Century

4 Mircea Eliade, *The Forge and the Crucible*, 1956

46

5

"Coal deposits from the Carboniferous
Period are found in Europe, Asia and
North America, i.e. the areas that
formed the ancient Laurasian continent.
During the Carboniferous Period
Laurasia was located near the equator,
where the conditions were favorable
for tropical forests. The minerals you
are using have very likely existed
already in the Carboniferous Period.
Each mineral is created under certain
conditions, such as with any mineral,
the right conditions occur at different
times in different parts of the world.
Thulite is found for example in
Norway, where the bedrock was formed
just before the Carboniferous Period.
Mountain crystal is a colorless variety
of quartz and common all around the
world. It is also found in Finland's
over two billion-yearold bedrock. With
certainty, one can say that the rock
crystals have existed already in the
Carboniferous Period."

5 Saija Saarni,
Geologie-Doktorantin,
Universität Turku in
Finnland in einem
E-Mail-Gespräch über
die Themen der Werke,
2018
Saija Saarni, Ph.D.
Researcher in Geology,
University of Turku,
Finland, in an e-mail
conversation about the
themes of the works,
2018

6 Heiko Achilles,
Karbonwald-Simulation
Heiko Achilles,
Carboniferous Forest
Simulation

6

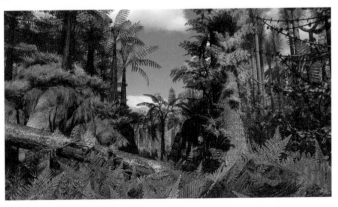

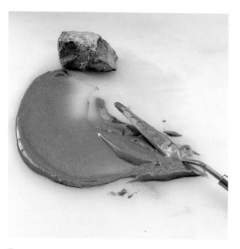

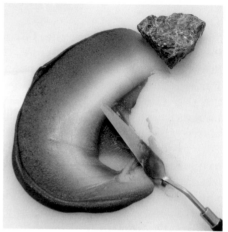

7

8

9

"Stones think in thousands of years."

"Ultramarine was laboriosly extracted from the precious stone lapis lazuli. (…) As befits a stone with heavenly associations, lapis was described in terms of the night sky. Lapis' white clouds were made of minerals such as calcite. (…) The star-like specks were actually golden crystals of pyrite. As stars and clouds, these gold and white minerals may have reinforced the stone's heavenly character, but they posed a problem for the artist who wanted to grind it up and use it as a blue pigment. (…) There are numerous recipes for purifying lapis (…) painter Cennino Cennini wrote a particularly detailed version of this type of recipe. (…) The recipe gives the blue, the white and the gold an opportunity to move around and change their circumstances if they so wish."

11

12

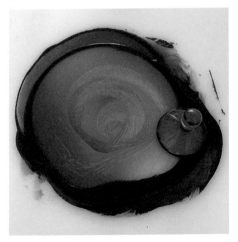

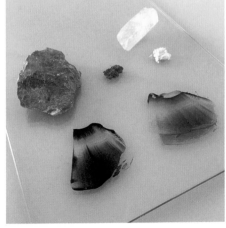

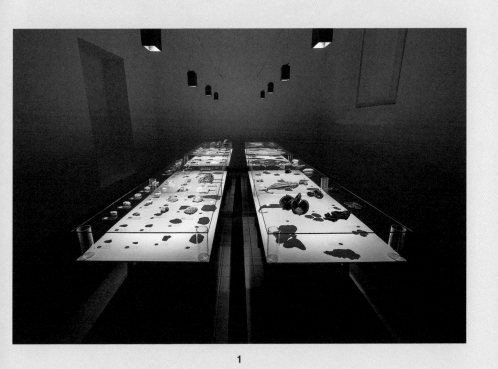

1

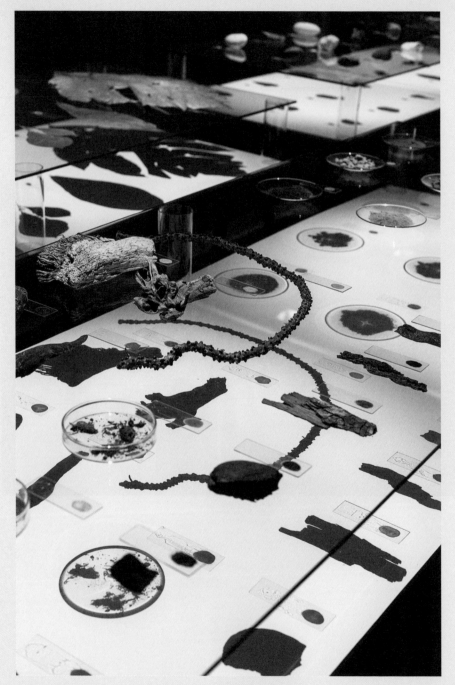

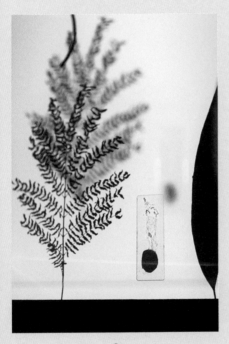

3

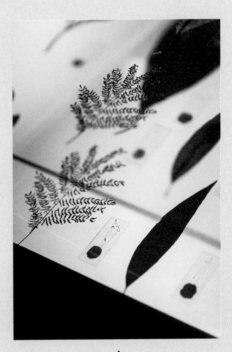

4

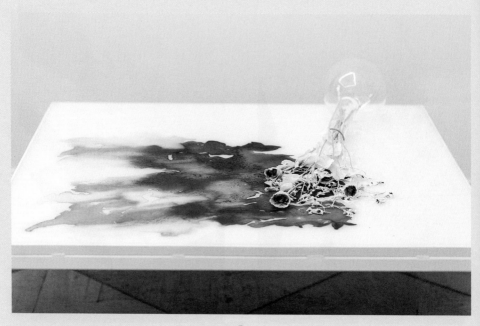

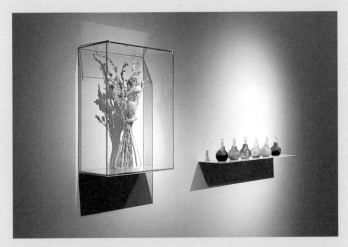

6

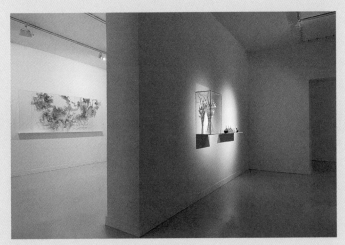

7

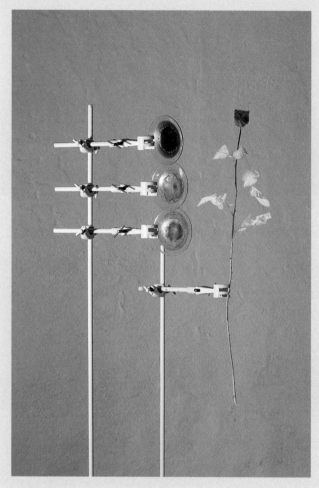

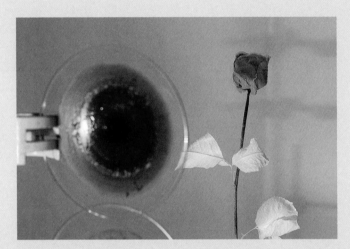

9

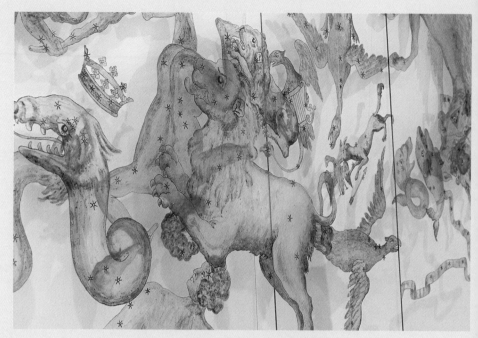

10

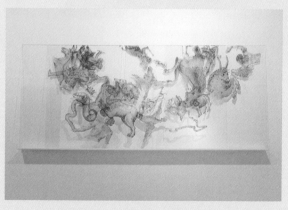

11

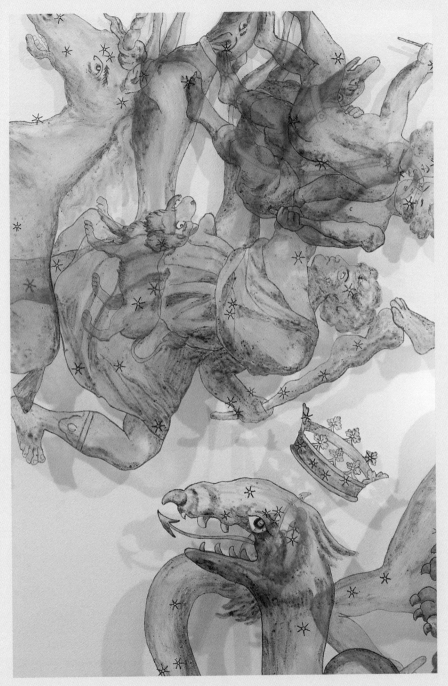

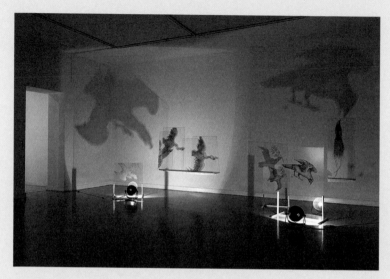

13

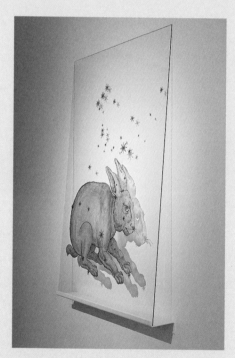

14

1–4
Buni Buana (Hidden World)
Natürliche Materialien,
gesammelt in Indonesien und
Farben destilliert oder gemahlen
aus diesen, Glas, Transparente
Farben, Licht
2014–2015, 400×180×100 cm
Für die Installation wurden
verschiedene natürliche
Materialien in Java, Indonesien,
gesammelt: Steine, Pflanzen,
Erde, Vulkanasche, aber auch
Korallen und Muscheln, die
an den Strand gespült wurden.
Aus jedem dieser Elemente
wurde eine Farbe auf einen
Objektträger destilliert oder
gemahlen. Zusätzlich wurden
mit transparenter Farbe
Abbilder von Naturgeistern auf
diese Platten gemalt. Diese
Geistergestalten, verwurzelt in
lokaler animistischer Tradition,
werden durch ihre Schatten
sichtbar und enthüllen somit
eine versteckte Ebene
natürlicher Wirklichkeit.
Buni Buana (Hidden World)
Natural elements collected from
Indonesia and colors distilled
or ground from them, glass,
transparent paint, lights
2014–2015, 400×180×100 cm
For the installation various
natural elements were collected
in Java, Indonesia: rocks, plants,
soil, volcanic ash as well as
corals and shells which had
drifted onto the beach. From
each element, a color sample
was distilled or ground onto
a microscopic slide. In addition,
images of nature spirits were
painted on the slides with a
transparent paint. These painted
spirits, related to local animist
traditions, become visible only
through their shadows, in this
way revealing a hidden layer of
nature's reality.

1
Ausstellungsansicht: Adiacenze,
Bologna, Italien, 2015
Exhibition view: Adiacenze,
Bologna, Italy, 2015

5
*Everything Vanishes, Except
Life Itself*
Gebleichte Rosen und
Rittersporn, ihre destillierten
Farben, Glas
2014, 60×100×100 cm
Die Künstlerin destillierte die
Farben von roten Rosen und
blauem Rittersporn. Nur die so
erzeugten Farben verwendend
malte sie einen Schwall
von Farbe auf einen weißen
Tisch. Zusätzlich bleichte die
Künstlerin die verwendeten
Blumen. Diese werden in einem
Glasbehälter neben der Malerei
gezeigt.
*Everything Vanishes, Except
Life Itself*
Bleached roses and
delphiniums, their distilled
colors, glass
2014, 60×100×100 cm
The artist distilled colors from
red roses and blue delphiniums.
Using only these colors created,
she painted a splash of color
on a white table. In addition, the
artist bleached the very same
flowers. They are shown in a
glass vessel next to the painting.

6
*Flower Painting, the Act of
Immortalising*
Ein gebleichter Blumenstrauß
und seine destillierten Farben,
Isomalt, Glas
2017, 62×183×25 cm
Die Künstlerin destillierte die
Farben verschiedener Blumen
eines Straußes (Rosen, Nelken,
Löwenmäuler, Färberdisteln,
Hoher Rittersporn,

Chinesischer Rittersporn).
Anschließend wurde der
Blumenstrauß gebleicht. Die
destillierten Farben wurden als
Isomaltgemisch in Glasflaschen
erhalten und neben dem
gebleichten Blumenstrauß
ausgestellt.
*Flower Painting, the Act of
Immortalising*
A bleached bouquet and its
distilled colors, isomalt, glass
2017, 62×183×25 cm
The artist distilled colors
from the various flowers of a
bouquet (roses, dianthuses,
snapdragons, safflowers,
alpine delphiniums, chinese
delphiniums). After this, the very
same bouquet was bleached.
The distilled colors were
preserved as isomalt mixtures
in glass bottles and shown
next to the bleached bouquet.

7
Ausstellungsansicht: Ama
Galerie, Helsinki 2017
Exhibition view: Ama Gallery,
Helsinki, 2017

8–9
Study of Eternal Cycle
Eine gebleichte Rose und
ihre destillierten Farben, Glas,
Metal, Licht
2014, Dimensionen variabel
Die Künstlerin destillierte die
Farben von der Blüte und den
Blättern einer roten Rose.
Anschließend wurde dieselbe
Blume gebleicht. Nur die
starken roten Pigmente der
Blüte und die schwächeren
gelblichen Pigmente der Blätter
verwendend malte die Künstlerin
auf abgerundete Laborgläser.
Im Ausstellungsraum beleuchtet
ein Scheinwerfer das bemalte
Glas. So werden die Farben

auf die gebleichte Rose zurückreflektiert, welche wieder lebendig und rot erscheint.
Study of Eternal Cycle
A bleached rose and its distilled colors, glass, metal, light 2014, dimensions variable
The artist distilled the colors from the petals and leaves of a red rose. After this, the very same flower was bleached. Using only the strong red pigments of the petals and the weaker, yellowish pigments of the leaves, the artist painted three rounded laboratory glasses. In the exhibition space, a spotlight illuminates the painted glasses. In this way, the colors are reflected back to the bleached rose, which again appears vivid and red.

10–14
We Are All Made of Stardust
Stein- und Eisenmeteoritenstaub auf Glas
2016–2017, Dimensionen variabel
Stein- und Eisenmeteoriten wurden zu feinem Staub zermahlen. Aus Steinmeteoriten, Achondriten und Chondriten, wurde ockerbrauner Staub gewonnen, während aus den Eisenmeteoriten, Pallasiten und Mesosideriten ein dunkelgrauer Staub gemahlen wurde. Mit diesem Metoritenstaub malte die Künstlerin verschiedene tierische, pflanzliche und menschliche Figuren, inspiriert von Illustrationen und Konstellationen aus einem Sternenatlas aus dem 17. Jahrhundert, auf Glas.
We Are All Made of Stardust
Stone and iron meteorite dust on glass
2016–2017, dimensions variable
Stone and iron meteorites were finely crushed into dusts. From stone meteorites, achondrites and chondrites, an ocher brownish dust was crushed, whereas from iron meteorites, pallasites and mesosiderites, a dark gray dust was crushed. With the meteorite dusts the artist painted various animal, plant, and human figures from 17th-century star atlas illustrations of constellations on glass.

10–12
We Are All Made of Stardust (Northern Hemisphere)
Stein- und Eisenmeteoritenstaub auf Glas
2017, 100×245 cm
We Are All Made of Stardust (Northern Hemisphere)
Stone and iron meteorite dust on glass
2017, 100×245 cm

13
Ausstellungsansicht: Ama Galerie, Helsinki 2017
Exhibition view: Ama Gallery, Helsinki, 2017

14
We Are All Made of Stardust (Lepus)
Stein- und Eisenmeteoritenstaub auf Glas 2016, 100×70 cm
We Are All Made of Stardust (Lepus)
Stone and iron meteorite dust on glass
2016, 100×70 cm

LAURA HIRVI ist in Deutschland in einer finnisch-deutschen Familie aufgewachsen und wurde zweisprachig aufgezogen. Sie studierte Ethnologie an der Freien Universität Berlin und der Universität Jyväskylä, Finnland. Im Jahr 2007 schloss sie ihr Studium an der Universität Jyväskylä mit einer Masterarbeit über die finnische Gothic-Subkultur ab. Während ihrer Doktorarbeit über die Sikhs in Finnland und Kalifornien verbrachte sie ein Jahr in Santa Barbara, Kalifornien, als Fulbright-Studentin. Im Jahr 2013 erhielt sie einen Doktortitel in Ethnologie von der Universität Jyväskylä. In ihrer Postdoc-Forschung studierte sie u.a. „Mobile finnische Künstler und Berlin". Laura Hirvi wurde 2015 zur Direktorin des Finnland-Instituts in Deutschland mit Sitz in Berlin ernannt.

LAURA HIRVI grew up in Germany in a Finnish-German family and was raised bilingually. She studied ethnology at Freie Universität Berlin and University of Jyväskylä, Finland. In 2007, she gradutated from the University of Jyväskylä with a Master's thesis on Finnish Gothic Subculture. During her PhD research on the Sikhs in Finland and California she spent a year in Santa Barbara, California, as a Fulbright student. In 2013, she received a PhD in Ethnology from the University of Jyväskylä. In her postdoctoral research, she studied i.a. "Mobile Finnish artists and Berlin". In 2015, Laura Hirvi was appointed director of the Finnish Institute in Germany, located in Berlin.

CHRISTINE NIPPE forschte für ihre Dissertation als Visiting Scholar an der Columbia University, New York. Promotion zu einer Fragestellung an der Schnittstelle von Stadtanthropologie, Kultur- und Kunstwissenschaften, Humboldt Universität zu Berlin. Sie publizierte ihre Dissertation unter dem Titel „Kunst baut Stadt. Künstler und ihre Metropolenbilder in Berlin und New York" (transcript Verlag) und arbeitet seit 2007 als Ausstellungsmacherin für z. B. die 5. Prag Biennale, das Center of Contemporary Art Thessaloniki, Stills Edinburgh, Museum Angewandte Kunst Frankfurt/Main und das Finnland-Institut in Deutschland. Seit April 2018 ist sie Programmkoordinatorin und Kuratorin für die Schwartzsche Villa des Fachbereichs Kultur Steglitz-Zehlendorf.

CHRISTINE NIPPE was a Visiting Scholar at Columbia University, New York for her dissertation. She wrote her PhD on a question at the intersection of urban anthropology, cultural studies and art studies at the Humboldt University Berlin. She published her dissertation under the title „Kunst baut Stadt. Künstler und ihre Metropolenbilder in Berlin und New York" (transcript Verlag) and has since 2007 been working as a curator for exhibitions such as the 5th Prague Biennale and at the Center of Contemporary Art Thessaloniki, Stills Edinburgh, Museum Angewandte Kunst Frankfurt/Main as well as at the Finnish Institute in Germany. Since April 2018 she is a programme coordinator and curator at the Schwartzsche Villa of the Steglitz-Zehlendorf Department of Culture.

ELSA SALONEN (geb. 1984 in Turku, Finnland) absolvierte 2008 die Akademie der Bildenden Künste in Bologna, Italien. In den letzten zehn Jahren hat sie hauptsächlich aus Berlin gearbeitet. Ihre Praxis ist geprägt durch regelmäßige Aufenthalte in Künstlerresidenzen wie Puerto Contemporáneo (2018), Lugar a Dudas (2016) in Kolumbien und SewonArtSpace (2014) in Indonesien. Salonen hatte verschiedene Einzel- und Gruppenausstellungen in ganz Europa und ihre Werke sind Teil von Museumssammlungen wie Wäinö Aaltonen Museum, Saastamoinen Foundation (Finnland) und Lissone Museum of Contemporay Art (Italien). Sie erhielt Preise wie den National Art Award Italy und den Artist Grant Finland.

ELSA SALONEN (b.1984 Turku, Finland) graduated from the Fine Arts Academy of Bologna, Italy, in 2008. The last decade she has worked mainly from Berlin. Her practice is marked by regular work periods in artist residencies like Puerto Contemporáneo (2018) and Lugar a Dudas (2016) in Colombia and SewonArtSpace (2014) in Indonesia. Salonen has had various solo and group exhibitions throughout Europe and her works are part of museum collections such as Wäinö Aaltonen Museum, Saastamoinen Foundation (Finland) and Lissone Museum of Contemporay Art (Italy). She has received such awards as the National Art Award Italy and the Artist Grant Finland.

IMPRESSUM / IMPRINT

Dieser Katalog erscheint anlässlich der Ausstellung / This catalog was published on the occasion of the exhibition
Elsa Salonen, Stories Told by Stones
15.02. – 31.03.2019
Schwartzsche Villa
Grunewaldstraße 55
12165 Berlin-Steglitz

Konzept / Concept:
Christine Nippe & Elsa Salonen

Grafische Gestaltung / Graphic Design:
Wolfgang Hückel,
Katharina Tauer

Lektorat / Copy Editing:
Betsy Dadd, Lukas Heger, Marion Holtkamp, Claudia Nierste, Emmi Salonen, Fanny Thalén

Texte / Texts:
Laura Hirvi, Christine Nippe, Elsa Salonen

Übersetzung / Translation:
Michael Wetzel, Berlin

Fotografien / Photos:
Ludger Paffrath, Berlin,
Jere Salonen, Turku

Produktion / Production
Dr. Cantz'sche Druckerei
Medien GmbH

Herausgegeben von / Edited by:
Christine Nippe
Bezirksamt Steglitz-Zehlendorf von Berlin
Amt für Weiterbildung und Kultur
Fachbereich Kultur
Grunewaldstraße 3
12165 Berlin
Tel +49 (0)30 90299 2212
www.kultur-steglitz-zehlendorf.de

Leitung der Abteilung / Head of Department:
Frank Mückisch

Leitung des Fachbereichs Kultur / Head of the Cultural Department:
Dr. Brigitte Hausmann

In Zusammenarbeit mit / In collaboration with
Finnland-Institut in Deutschland / The Finnish Institute in Germany

© 2019 Bezirksamt Steglitz-Zehlendorf von Berlin, Amt für Weiterbildung und Kultur, Fachbereich Kultur, Finnland-Institut in Deutschland
© 2019 für die abgebildeten Arbeiten / for the reproduced works: Elsa Salonen
© 2019 für die Texte bei den Autorinnen und dem Übersetzer / for the texts the authors and the translator

Alle Arbeiten / All works:
Courtesy of Elsa Salonen
und / and Ama Gallery, Helsinki

Erschienen in der / Published by:
Edition Cantz
Dieselstraße 50
73734 Esslingen
www.edition-cantz.de

ISBN 978-3-947563-37-1

Gedruckt in Deutschland
Printed in Germany

Gefördert aus Mitteln des Ausstellungsfonds für die Kommunalen Galerien der Berliner Bezirke, des Bezirkskulturfonds und dem Finnland-Institut in Deutschland.

The project is generously supported by the Ausstellungsfonds für die Kommunalen Galerien der Berliner Bezirke, the Bezirkskulturfonds, and The Finnish Institute in Germany.

DANK
ACKNOWLEDGEMENTS

Dem Team der Schwartzschen Villa, Fachbereich Kultur Steglitz-Zehlendorf. Laura Hirvi, Essi Kalima und dem Team des Finnland-Instituts in Deutschland sowie dem Art Promotion Centre Finland. Danke, Graham Harvey. Danke an die Familie, Danke an die Freunde – ich liebe Euch. Und vor allem Danke an das Reich der Mineralien.
The team of the Schwartzsche Villa, Department of Culture Steglitz-Zehlendorf. Laura Hirvi, Essi Kalima and the team of the Finnish Institute in Germany as well as the Art Promotion Centre Finland. Thank you, Graham Harvey. Thanks to the family, thanks to the friends – I love you. And above all, thanks to the mineral kingdom.

Elsa Salonen

FINNLAND-INSTITUT
IN DEUTSCHLAND

Schwartzsche Villa

Bezirksamt
Steglitz-Zehlendorf be Berlin

Senatsverwaltung
für Kultur und Europa be Berlin